D0892830

THE LITTLE BOOK OF GROWING UP

Vic Parker

Hodder
Children's
Books

A division of Hachette Children's Books

Get ready to be gorgeous

Heard the story of the ugly
duckling? She hid away because
she felt small, plain and unconfident.
However, she grew up fast.
So fast, she didn't
realise it was happening. She
developed into a beautiful swan,
admired by everyone.

None of us is an ugly duckling, but we all have times when we feel like one. And like her, we all grow up and blossom. We change without realising, between the ages of about nine and 17. Doctors call this time 'puberty', which means 'changing into a grown-up'. It is when girls develop into young women and boys develop into young men.

Body talk

Changing into a grown-up is
an exciting time. There are lots
of great things to look forward
to, such as: going out to
parties and discos, going
on holiday with your friends,
learning to drive, and falling
in love.

However, growing up
can sometimes be an
anxious time too.

This is because changes happen to our bodies. For instance, girls develop boobs and boys' voices get deeper. Changes like this can make us feel strange and awkward for a while. But when we get used to them, they can be wonderful. They can turn the plainest girl into an attractive young woman, and the most awkward lad into a confident young man.

Ready, steady, grow!

No one can tell you when you
will begin to grow up. Your
body will decide in its own time.
Some girls' bodies start
developing at nine or earlier.
Other girls' bodies don't start
developing till 14 or later.

Whenever your body starts
developing, the changes
will happen gradually, over
several years.

And remember, it's normal to
be different. We're all
different sizes and shapes. We all
have different skin, hair and eye
colour. We're all good at
different things, from dancing to
drawing, from horse-riding to
helping people. So it's normal
that you and your friends will
grow up in different ways at
different times.

The tall and short of it

In general, girls' bodies usually
start developing before boys'
bodies. For instance, soon after
starting secondary school, most
of the girls in your class will grow
taller than the boys. A year or
two later, many of the boys will
catch up and overtake.

By the time you and your friends leave school, most of you will be the height you will stay for the rest of your lives. Whether you end up tall or small, you can be beautiful. Top tennis player Venus Williams and movie star Nicole Kidman are taller than most men. Ballet dancer Darcey Bussell and pop star Kylie Minogue are tiny. All of them stand proud and look gorgeous.

Shaping up

During your time as a teenager,
as well as growing upwards, your
body will also fill outwards.
You will develop a fabulous,
womanly shape.

Slowly, over several years, you
will grow boobs. Also, your hips
will gradually get wider and your
bum will get fuller.

This does not mean that you will get fat. It means that you'll become a babe with a fantastic figure. You can go on fun shopping trips for pretty bras and matching knickers. And you'll look even better in your jeans than you do now.

Is bigger better?

Your boobs will begin just as
little mounds. They will get
bigger and change shape
very slowly during your time at
secondary school.
Don't be alarmed if one boob
seems at first to be growing
bigger than the other. Later, they
nearly always even up – just about!

There's no way of telling if you're going to end up small and perky or big and bouncy. Remember there's no right or wrong size and shape. Be happy with your figure. Even if you don't like it, there will be loads of other girls who wish they look just like you.

Fit and fragrant

To stay confident with your
body while you become curvier,
exercise regularly. Try fun things,
such as: ice-skating, swimming,
bike-riding, dog-walking, helping
at a riding stables, yoga,
aerobics, or salsa dancing.

Always put your underclothes
and socks or tights in the wash
after each wear. This is because
you sweat more as you grow up,
especially when you exercise.
Make sure you have a shower or
bath every day, and use a
deodorant spray or roll-on lotion
under your arms. That way, you'll
not just look and feel great,
you'll smell great too.

Zap zits

One of the downsides to being a cool teenager is that you can get spots now and again. These can break out on your face, chest and back. Boys can get spots just the same as girls.

Having spots doesn't mean that you're dirty. It's just that the changes going on inside you sometimes unbalance your body. If you get a spot, never squeeze it, or it might leave a tiny scar. Instead, you can get special creams from the chemist to clear spots up fast. If you're bothered by a bad outbreak, your doctor can work wonders.

Sensational skin

Even models, pop stars and actresses get spots from time to time. However, they know lots of top tips to keep their skin looking as smooth, soft and peachy as possible.

- Drink at least six glasses of plain water a day.
- Eat plenty of fresh fruit and vegetables.
- Wash your hands often, so you don't carry germs to your face.
- Keep your face clean by using a gentle wash, lotion or wipe.
- Let your skin 'breathe' by not wearing make-up often.
- If you get a spot on an important occasion, dab a concealer cream on to it to cover it up.

Luscious locks

Everyone wants healthy,
shiny hair. Unfortunately,
while you're growing up, your
hair can sometimes become a
bit greasy and lank.

If this happens, rest assured
that your hair won't stay
lifeless for ever.

After a year or two, it will return
to the glorious mane it once was.
In the meantime, try swapping
your usual shampoo for one
especially for greasy hair. Wash
your hair regularly to keep it
clean and sweet-smelling.

Hair flair

Models, pop stars and actresses
know that a change of hairstyle
can make you feel fantastic. So
why not try a brand new look?

Long hair can look flat and boring
when it's down. So experiment
with up-dos, such as plaits,
ponytails and twists.

Use a sparkly clip or bright
band to draw attention away
from limp locks. Or ask a
hairdresser to give you a more
grown-up, shorter cut. You'll
wow everyone with the chic
new you. Go for a style that's
easy to look after, and you'll have
more time for beauty sleep.

Fluffy stuff

It's not just the hair on your head that can be an issue when you're growing up. Teenage girls and boys find that soft hair begins to grow in all sorts of other places too.

Over several years, you will develop hair under your arms. Hair will also grow over your private parts, between your legs. (This is called pubic hair.) Boys will sprout hair on their faces and will need to start shaving. Girls can find that hairs on their legs and upper lip get darker and thicker. These can be more noticeable if you have dark skin.

Smooth and sleek

Body hair is perfectly natural.
However, sometimes grown-ups
choose to remove some of it. For
instance, many women dislike
pubic hair that shows when they
wear a swimsuit. They call this
their 'bikini line'.

If you are bothered by your body
hair, there are lots of ways you
can get rid of it.

These include: tweezers, women's razors, and special creams, waxes and bleaches. Different methods are good for different parts of your body. Some can be quite tricky to use safely. So always ask for advice from a grown-up such as your mum, your friend's mum, your auntie, or your big sister. And don't rush into removing body hair, because once you've started, it can be hard to stop!

Looking ahead

So why do all these changes
happen to our bodies as we
grow up?

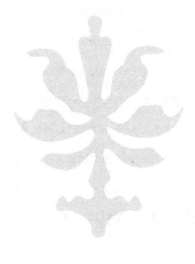

The biggest difference between young people and grown-ups is that girls and boys can't have babies together, but women and men can. It's the changes that take place to our bodies between the ages of about nine and 17 that make it possible for us to have babies when we're grown up.

Spot the difference

It's easy to spot changes like height, curves, spots, and body hair. These happen on the outside of our bodies. But as we grow up, many other changes take place inside us.

We can't see the changes inside us, so we don't realise they are going on. When they finally show, it can be quite a surprise. They often seem to happen overnight. A boy might find one day that when he speaks, his voice is much deeper and richer than the day before. Or a girl might wake up to discover that she has started having periods.

What is a period?

A period is a bit of blood that
comes from between your legs
over four to five days every
month. It may sound scary, but
don't worry. It means your body
is working the right way.

For girls, starting periods is
the most important change in
growing up. It means that your
body is ready for you to have a
baby one day – if you want one,
that is. You certainly don't have
to have one just because you've
started having periods. It's a
choice that you can make
when you're older.

Join the club

Men don't have periods. Boys'
insides change in other ways
so that they can have a baby with
a woman when they are
grown up. Periods are special
things just for girls.

All women are meant to
have periods at the right time
in their lives.

That includes your mum, your
friends' mums, your friends, your
aunties and your teachers.
It includes pop stars, shop
assistants, actresses, female
doctors, sportswomen, TV
presenters – even women vicars
and nuns. It includes women
who aren't married and women
who are. Women who have
had babies and women who
haven't. Women in every country
all over the world.

Perfectly private

There's no need for periods to be messy. There are special pads which fit inside your knickers and soak up the blood. No one can tell when you are wearing a period pad.

A period pad is a comfortable shape. It has a sticky strip underneath, so it fixes firmly in place in your knickers.

You can change the pad whenever you like. Just wrap it in some loo roll or the packet it came in and throw it into a bin. Period pads are sold by supermarkets and chemists. Most newsagents, late-night shops and petrol stations stock them too.

Grown-up news

You may be wondering why
you haven't heard about
periods before.

Well, having a period is not a big
mysterious secret.

It's something that all grown-ups know about. (Yes, men as well as women.) All young people gradually find out how their body works as they get older. Now you are grown up enough to find out more about yours – so, well done!

Girl talk

You might feel a little embarrassed about periods at first. Most girls do. So you can bet that all your friends will feel like you. Talking things over with them can really help.

It's also a great idea to speak about periods with a woman you trust, such as: your mum, your friend's mum, your auntie, your older sister, your favourite teacher or care worker. Don't forget, when they were your age, they also probably felt a bit upset and worried about periods. Now they can answer your questions and tell you about their own experiences. This will make you feel a lot better.

Talk tips

Here are ways you can get
talking about periods with a
trusted grown-up. (The last four
are good if you live with your
dad rather than your mum. But
you might still want to talk to
a woman as well.)

- Ask your mum/auntie/big sister what age she started having periods.
- At the library, say: 'I wonder where the books on starting periods are?'
- When you see a period pad advert, say: 'I wonder when I'll need one of those.'
- When shopping, ask where the period pads are.
- Add period pads to your family shopping list.

Squeamish?

Don't worry if you don't like the
sight of blood. Period blood
often doesn't look like the blood
you see when you cut yourself.

At the start and end of your
period, the blood is often quite
thick and a brownish colour.

And overall, there isn't usually a lot of blood to see. During your whole period, you lose only about an eggcupful of blood – and it flows out over four or five days. So having a period isn't much like usual bleeding at all.

Right and bright

Just because you lose blood
during a period it does not mean
that you're ill. In fact, it means
the opposite: you are healthy.

Period blood is a sign that your
body is working as it should.
It tells you that you are growing
up correctly.

Having a period will not make your body weak and likely to pick up illnesses. For instance, you are not more likely to catch a cold during your period than at any other time during the month. You can stay glowing and gorgeous.

Food for fitness

In order to make blood, your body needs iron. Iron is found in green vegetables, breakfast cereals and red meat. So make sure you eat plenty of these foods to stay well and strong.

If you are vegetarian, you don't have to eat red meat. Spinach, watercress, lentils, beans and wholegrain bread are all full of iron.

So are dried apricots, which make a tasty snack. If you are eating foods like these and you feel tired and run down, tell your doctor or school nurse. They may perhaps decide you need iron tablets for a while to bring back your sparkle.

Periods – a pain?

Many girls get some tummy-ache when their period starts. This can be useful, because it tells you when it's time to go to the loo and stick a period pad in your knickers.

However, sometimes, the pain might spread to your back and your knees and make you feel quite fed up.

This is called period pain. Occasionally, you may feel a bit faint and need to go to lie down. But this usually only happens on the first day of your period for a little while. The rest of the time, you might not even notice that your period is happening.

Banish the blues

If you get period pain, there
are several things you can do to
get rid of it, so you can carry on
living your life as normal.

- Do some exercise, such as dancing, netball or dog-walking.
- Lie down with a hot-water bottle or sticky heat patch on your tummy.
- Ask a grown-up for one or two of the mild painkillers they use for headaches.

All of these things should get rid of period pain within an hour or two.

Splish, splash, splosh!

Having your period does not
mean that you are dirty. If you
change your period pad every
few hours and wash, shower or
bath as usual, you'll stay fresh
and fabulous.

There is no problem with taking off your knickers and period pad for a short time to have a shower. And when you lie in a bath, the water pressure stops your period flowing for a while anyway. Before you shower or bath, wipe between your legs with loo paper. Afterwards, dry between your legs with loo paper too. Put on a fresh period pad and you're good to go.

Spoiled for choice

Just as there are lots of different types of eyeshadow and nail varnish, there are lots of different types of period pad too.

Some pads have sticky 'wings' to press around the sides of your knickers as well as a sticky strip underneath.

Some pads are very narrow, so you can wear them with thong-style knickers. Some pads are thick: they're good for extra protection at night-time. Some pads are very thin: these 'panty liners' are good for wearing when your period is due, just in case, or at the end of your period when the flow is lighter.

Another option

Some girls prefer to use tampons
to period pads. A tampon is a roll
of cotton wool the size and
shape of a lipstick or mascara.
You slip it inside your body
where the blood comes out.

A tampon works by soaking
up period blood before it leaves
your body.

It doesn't hurt to put a tampon in, and when it is in place inside you, you can't even feel it is there. A tampon has a long string, so the end stays outside you. You don't notice it at all. When you want to change a tampon, you just pull on the string and the tampon glides out.

Tried and tested

Most girls start off with period pads and wait till later to try tampons, because period pads are easier to start with. But if you want to try tampons straight away, that's fine.

Every pack of tampons comes with clear instructions what to do. Some girls ask their mums or older sister to help them out the first time. Once you get the hang of it it's very easy. On the other hand, if you don't like the sound of tampons, you don't ever have to use one. It's entirely up to you.

Take the plunge

There's no reason why you can't
do all your usual activities when
you have your period, whether
it's horse-riding, ice-skating,
ballet dancing or karate.

You can even swim, if you want
to. However, you can't wear a
period pad in a swimsuit as it
will get soggy.

As long as your period is not too heavy, you'll be fine without a pad while you swim, as the water pressure stops the blood flowing, the same as in the bath. (But don't hang around on the poolside!) Or, you can wear a tampon. But if you have a swimming lesson and you'd rather not swim, tell your teacher that you've got your period and they will understand.

A date with fate

There is no set age for girls to
have their first period. Most girls
start between 11 and 14.
However, some girls start at
eight, nine or ten. Other girls
start at 15, 16 or 17.

Try not to be anxious about when you will get your first period. It will happen whenever your body is ready. You might perhaps start your periods at the same age as your mum started hers – but you'll have to wait and see!

Clued up

Your body might give you some signs that will help you to guess when you might start your periods. You almost certainly won't have your first period until:

- a year or two after you have begun to develop boobs
- after you have started to grow under-arm and pubic hair
- after you see whitish stains in your knickers

The whitish stains are made
by a small amount of wet,
sticky stuff called mucus coming
from between your legs. This
is perfectly normal. It shows
that your insides are
working healthily.

Be prepared

You can get your first period at any time. If you're not home, you might be having a sleepover at a friend's, or at school, or at the shops, or at a dance class.

So it's a good idea to carry a period pad in your school bag or sports bag, just in case. Women always carry pads or tampons in their handbag. Period pads often come folded in patterned wrappers. So if you pop one in your bag and somebody notices it, they will think it's a packet of tissues. Clever, eh?

Shopping shyness

Shops usually call period pads
and tampons 'sanitary towels' or
'sanitary protection'. You could
ask your mum, auntie, big sister
or older friend to buy your first
ones for you. Or ask them to
help you choose.

When you come to pay, don't be put off if the checkout assistant is a man. Over half the people in the world are women, and they buy period pads in shops every day. Male checkout assistants put period pads through the tills all the time, without thinking anything of it. So be brave and bold and go for it.

The big day

Sooner or later the day will come when you get your first period. It may not look like blood to start off with. You might just notice brown stains in your knickers.

Getting your first period is an important landmark in growing up.

It's a good idea
to tell a grown-up you love
and trust, such as your mum or
dad, your auntie, your big sister,
or your care worker. They will
be very proud and pleased for
you. In some countries, such
as America, families even
throw parties to celebrate the
special event.

Sleep tight

Your period won't necessarily start during the day. It can start at night-time too. So don't be alarmed if you wake up to find blood spots on your nightclothes or the sheet. This happens to everyone from time to time.

Once you've had your period a few times you'll be able to guess roughly when you might get your period, so you can wear knickers and a period pad in bed just in case.

You'll need to wear
knickers and a pad for however many
nights your period lasts. But you don't
need to wake up to change your pad.
Less blood flows out at night than in
the daytime, because you're lying flat.
Besides, you can buy night-time pads
which are specially made to last the
whole time you are asleep.

Accident and emergency

If you're out when your period
starts and you haven't got a pad,
put a wodge of loo paper in your
knickers till you can borrow or
buy one. Most ladies' loos have a
wall machine that sells them in
ones and twos.

Very occasionally, you might
not realise that you have started
and a few spots of blood might
show up on the back of your
skirt or trousers.

A true friend will always tell you this before anyone notices. Then you can either sponge the stain off your clothes, or tie a jumper around your waist until you get somewhere you can change. Nice people would never make fun of you. And nasty people aren't worth worrying about.

All change

Women always take their
handbags into the loo with them,
so no one knows if they're
changing a period pad or not.
You can do the same, with your
school bag, sports bag or
party bag.

Period blood usually flows
heaviest at the start and gets
lighter as it goes on.

So for the first couple of days, change your pad every two or three hours. Towards the end of your period, you'll probably need to change your pad only two or three times a day. Some girls like to change their pad whenever they go to the loo. But you don't have to do this if you still feel dry and clean.

Period fashion

When you're next in a shopping centre or on the bus, look at all the women around you. It's impossible to tell who is having their period and who isn't!

Period pads aren't noticeable, so you can wear whatever you like when you have your period – even tight jeans or short miniskirts.

However, some girls like to wear dark-coloured knickers and clothes on the first days of their period. This is just in case a spot of blood leaks out of their pad and knickers and on to their clothes. This hardly ever happens, but some girls like to be on the safe side.

Learn the lingo

Girls and women have special
ways of telling each other they're
having their period. Many say
that they are 'on' or that they
have 'come on'.

Here are some more sayings:

- It's my time of the month.
- I've got the monthlies.
- I've got the curse.
- I'm on the rag.
- I'm on the blob.
- I've got the painters and decorators in!

Wonderful bodywork

So what goes on in your tummy
to make you have a period?

Well, girls' and boys' tummies have
the same tubes and organs for
digesting and absorbing food. But
they have a different set of tubes
and organs for making babies.

You have had baby-making equipment inside your tummy ever since you were born. However, it only starts working between the ages of about nine and 17. It is this that causes you to have periods. Isn't that amazing?

Take a look into your tummy

An important part of the
equipment inside your tummy
which makes you have periods is
your womb. This is the space inside
a woman where a baby grows.

Your womb is quite small. It's
only about as big as your clenched
fist. But the walls of your womb
are elastic.

So if one day when you're older
you decide that you want a baby,
your womb will easily stretch as the
baby grows bigger.

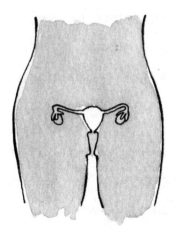

womb

What else is inside your insides?

From the top of your womb,

two tubes lead off left and right.

They are thin, like spaghetti.

They are not very long.

In fully-grown women each tube

is only about 10 cm.

Each tube ends near a little pod

called an ovary. Your two ovaries

are both filled with hundreds of

teeny-tiny eggs.

Every egg is only the size of the tip of a needle. An egg is the part of you that might grow into a baby one day when you're older.

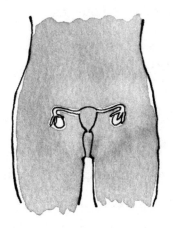

tubes and ovaries

A great escape route

From the bottom of your
womb, there is a small narrow
passageway which leads to the
outside of your body. This is
called your vagina.
(You say 'vadge-eye-nuh'.)

The vagina is what a baby travels
through when it is being born. Like
the womb, it is elastic. So when a
woman is having a baby, her vagina
can stretch much bigger than usual
to let the baby through.

The entrance to your vagina is a hole between your legs, between the hole where you wee and the hole where you poo. This is what period blood flows through.

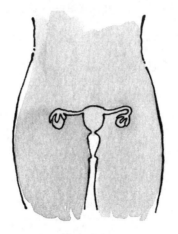

vagina

A magical process

Here's how all this special
equipment works. When your
body is ready, an ovary releases
an egg. The egg travels through
the nearby tube into your womb.
Your womb walls become
rich with blood, in case a
baby will grow.

When it isn't the right time to have a baby, the blood leaves your womb and flows out through your vagina, giving you a period. It flushes the egg out too. The egg is far too tiny to see. The whole process takes about a month. And as soon as your period has finished, your body does it all again. This is why girls get periods about once a month.

Periods are personal

After you have your first period,
you might miss a month or two
before you have another one.
You might also have a shorter
period one month and a longer
period the next month.

As the months go on, these
changes usually settle into a
regular pattern.

Your body will decide its own timetable. Many girls come on every 28 days and their periods last four to five days. But some girls come on every 24 days, while others come on every 32 days. Some girls' periods last three days, while other girls' periods last seven days. Remember, it's normal to be different.

Calendar counting

Doctors have a special name
for your personal pattern of
monthly periods. They call it
your menstrual cycle.
(You say 'men-stroo-al' cycle.)
'Menstrual' means periods and
'cycle' means something that
happens over and over again.

You can work out your menstrual
cycle by marking days in your
diary or on a calendar.
Mark the first day of your period

as Day 1. Then count up until
you get your next period. The
first day is Day 1 again. The
pattern that forms over several
months will help you be
prepared for getting your period.
But don't worry if you don't see a
pattern. Some girls always have
irregular periods.

Getting the grumps

In the few days just before your period, the changes going on in your body can make you feel moody and weepy. Feeling like this has a special name: PMT (premenstrual tension) or PMS (premenstrual syndrome).

Some girls never get PMT at all. Others have it some months and not others. A few unlucky girls get it every month.

If you find yourself feeling really fed up before each period, try steering clear of chocolate, coffee, tea and fizzy drinks. You could also ask your doctor or school nurse about remedies such as vitamin B6 or evening primrose oil tablets. These things will soon have you back feeling like yourself all the time.

Do periods ever stop?

Most women have a period about once a month until they are around 50 years old. Then they stop for good.

Older women stop having periods because their time to have babies is over.

They no longer need periods, so their bodies stop having them. This time of life is called the menopause. Until then, having periods is a sign that you are healthy and that your body is working as it should.

Diet danger

Many girls and women worry a
lot about their weight. They think
they are fat, even if they are slim.
They go on diets and stop eating
all sorts of things in order to
become thinner.

This is not healthy for your body at all. It can make you very poorly in lots of ways, including stopping your periods. If you are anxious that you are fat, or worried about a friend who is not eating properly, talk it over with your mum, auntie, favourite teacher, doctor or school nurse. It is what they are there for, and they will know what to do to help.

Anxiety attack

Sometimes while you are
growing up, you can get very
worried about things like
schoolwork and exams, or
people rowing at home. If you
are extremely stressed, you
might stop having periods.

The answer is to share
your worries with someone
older that you trust.

Grown-ups know what it's like to be stressed and will understand. They may be able to do things to sort out your problem. If not, just talking things over can make you feel much, much better. There's no need to struggle through difficult times all on your own.

Training strain

It's great to keep in shape by working out two or three times a week. However, girls who do a lot of intense training for big sport or dance competitions can sometimes stop having periods.

If this happens to you, it means that you are working your body too hard or not eating the right food to cope with all your training.

You should tell your parents or your coach. Then they can help you eat the right things or change your training programme, so that your body gets back into tip-top form. After all, you need to be in perfect health to be a winner, don't you?

Pausing for pregnancy

Men do not grow eggs inside
their tummies. Instead, they
make thousands of tadpole-like
things called sperm. Each sperm
is even smaller than one of your
teeny-tiny eggs.

When a man and a woman
love each other and want a baby,
they have sex.

This is a special cuddle when the man's sperm go into the woman's vagina. Sometimes a sperm meets an egg in one of the woman's tubes and joins it. If this settles into the womb, it develops into a baby. Then the womb wall blood does not flow away. So when a woman is expecting a baby, she does not have periods.

Maybe baby

An egg can never grow into a baby on its own. So starting periods does not mean you might have a baby when you don't want to. You can only have a baby if you have sex.

If thinking about sex bothers you, put it to the back of your mind. It's great that you know about it, but now you can forget about it until you're older. But if you have lots of questions about sex, it's not rude or naughty to find out more. Tell a grown-up you trust that you've been wondering how babies are made. Or ask a librarian to show you where the right books are in the library.

Hands off!

As you grow into a beautiful babe, you'll get lots of admiring glances. It's nice to be chatted up, if you like the boy doing it. But sometimes a pushy boy or older man can make you feel uncomfortable or even fearful.

If anyone is behaving with you or touching you in a way you don't like, it is really important that you tell a grown-up what is happening.

It doesn't matter if you're complaining about a family member or friend. Explain to someone you trust how bad this person makes you feel. Then they will be able to help you or put your mind at rest, and you will soon be feeling much happier.

True or false?

Don't believe everything you hear older girls or boys saying about periods and having sex. Just because they're bigger than you, it doesn't mean they've always got it right.

Besides, sometimes people even pass round silly stories deliberately because they think it's naughty and fun. If you hear something and you're not sure whether it's right or wrong, don't be afraid to ask a grown-up you trust. They will be happy to help. Then you can look really cool setting everyone else straight.

The science bit

Doctors, nurses and science
teachers use proper medical
words for having periods and the
bits and pieces inside your body.
They'll think you're especially
clever if you know them. Here
are some to practise:

- having your period – menstruation

- egg – ovum

- tube – fallopian tube

- womb – uterus

- having sex – sexual intercourse

- expecting a baby – being pregnant

- missing a period when you're not
 expecting a baby – amenorrhoea
 (you say 'ay-men-or-ee-a')

A rollercoaster ride

Growing up can do strange
things to your feelings. One
minute you're on top of the
world. The next minute you're
down in the dumps.

It's the changes going on in your
body which give you great highs
and not-so-great lows.

So if you feel moody and fed up
now and again, it doesn't mean
you're going mad, or you're a
nasty person, or your life is no
good. It's a patch everyone goes
through. Your friends will be
feeling the same way. So
help each other through grey
days and enjoy sharing the
sunny times.

Finding freedom

As you grow up, it can be
hard for the people you live with
to let you go off doing things on
your own or with friends.
Because they care, they will
worry that something bad might
happen to you.

Your family will set rules about
going out, friends, clothes and
homework, which you might
disagree with.

If you scream and shout, you will look childish. It's best to discuss rules calmly. Then prove you can be trusted by sticking to them. Your family will see you are sensible and responsible. They will be proud of you and let you make more of your own decisions and do more things on your own.

Love – bliss or bother?

'Having a boyfriend' sounds quite important and official. It sounds like you need to do kissing and stuff. But it can just mean having a special boy that you enjoy activities with like swimming club or orchestra.

Having a boyfriend can be great at first. But after a while, things may go wrong.

You might start arguing, or he might fancy another girl. Splitting up happens to everyone – even models and pop stars. So do what they do: enjoy being with your friends and family, who love you very much. Plenty more good-looking boys will soon come knocking at your door.

Friends – together forever?

One of the best things about being a girl is having fantastic friends. But when you grow up, you might all go to different schools. You might end up liking different pop music or wearing different clothes.

Don't change yourself, just to fit in. It's natural to lose some

friendships as you grow up.
But you can make some great
new ones, too. Be yourself.
There are plenty of other girls
who would love to be special
friends with you. You just might
not have noticed them before.
And some friends will stick with
you, no matter what changes in
your lives. You will always have
great girly times together.

Cute, cool and confident!

No matter how old you get, there
will always be people to love and
look after you. Enjoy developing
into a clever, kind, gorgeous
grown-up. Lots of wonderful
times lie ahead.